Negative Detox

Mind clutter? Clear all negative thoughts with this coloring book.

by Frank Mejia Jr.

Content

1. Introduction
2. ASTRONOMICAL
3. ACCEPTANCE
4. ADMIRATION
5. ACCOMPLISHMENT
6. BELONGING
7. CALM
8. COMPASSIONATE
9. CONFIDENCE
10. CELEBRATE
11. DEPENDABILITY
12. DESERVEDNESS
13. ENCOURAGING
14. EQUALITY
15. FEARLESS
16. FULLNESS
17. GENEROSITY
18. GLORY
19. GIFT
20. HOPE
21. HEALTHY
22. INTEGRITY
23. ILLUMINATED
24. JOYFUL
25. KINDNESS
26. LUCRATIVELY
27. LEARN
28. MAGNIFICENT
29. NICE
30. OVERCOME
31. POSITIVE
32. PEACEFUL
33. QUALITY
34. RAINBOW
35. REMARKABLE
36. SERENITY
38. STRENGTH
39. TEAMWORK
40. THANKFULNESS
41. UNIFICATION
42. VIBRANT
43. WORTHINESS
44. WINNING

Introduction

I have design symmetry shapes named after positive words. I hope that while you are coloring your negative thoughts turn into positive ones.

When people detox, they work hard to remove impurities from the body. While we often hear about the pros of physical detoxes, we also need to understand the importance of mental detoxes. The body and mind work in harmony. No matter how clean your physical body is, if your mind is filled with toxins, you will still feel unclean, unclear, and unhappy.

Let's turn that around and work to better ourselves from head to toes. Enjoy your journey and thank you!

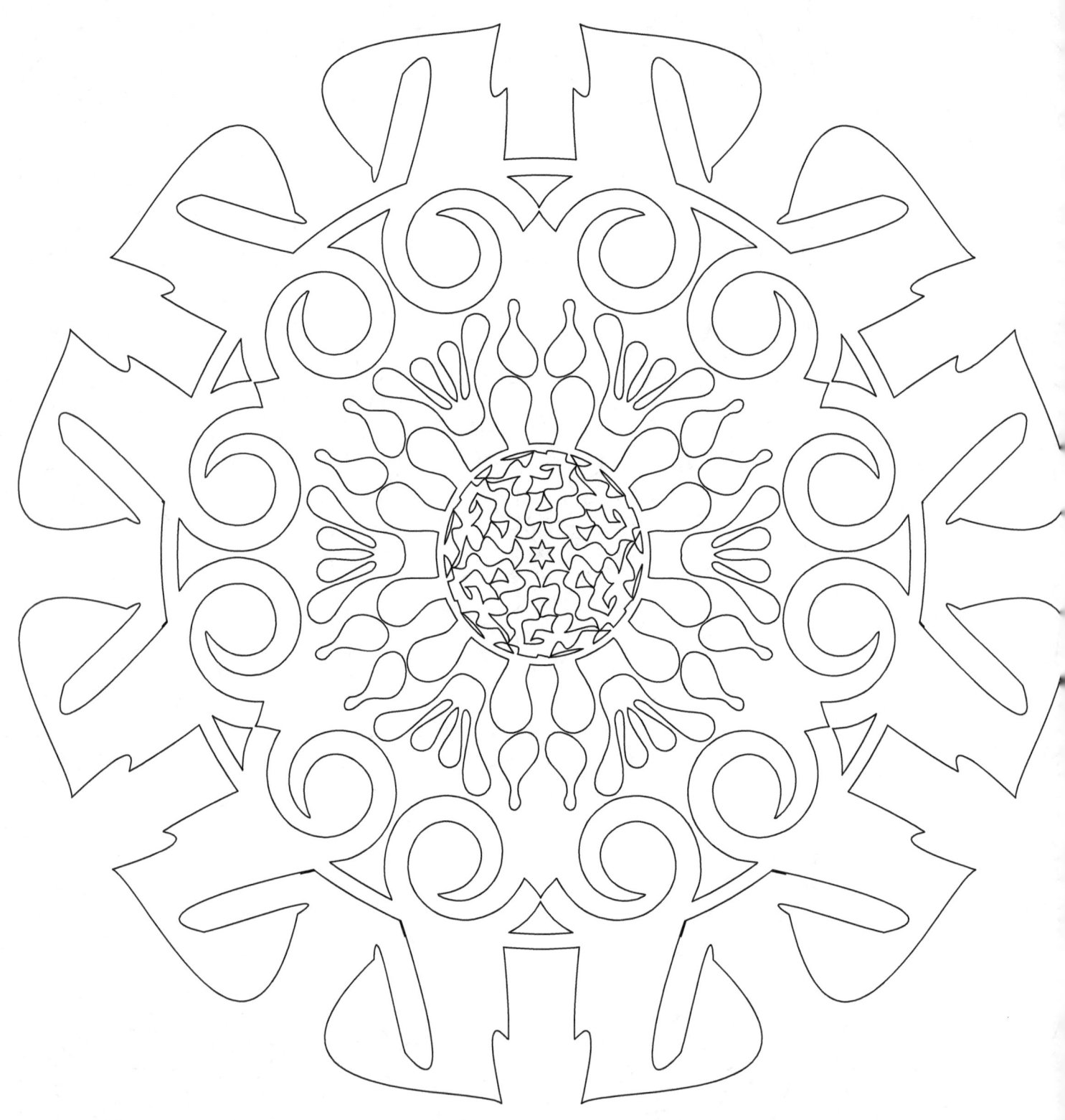

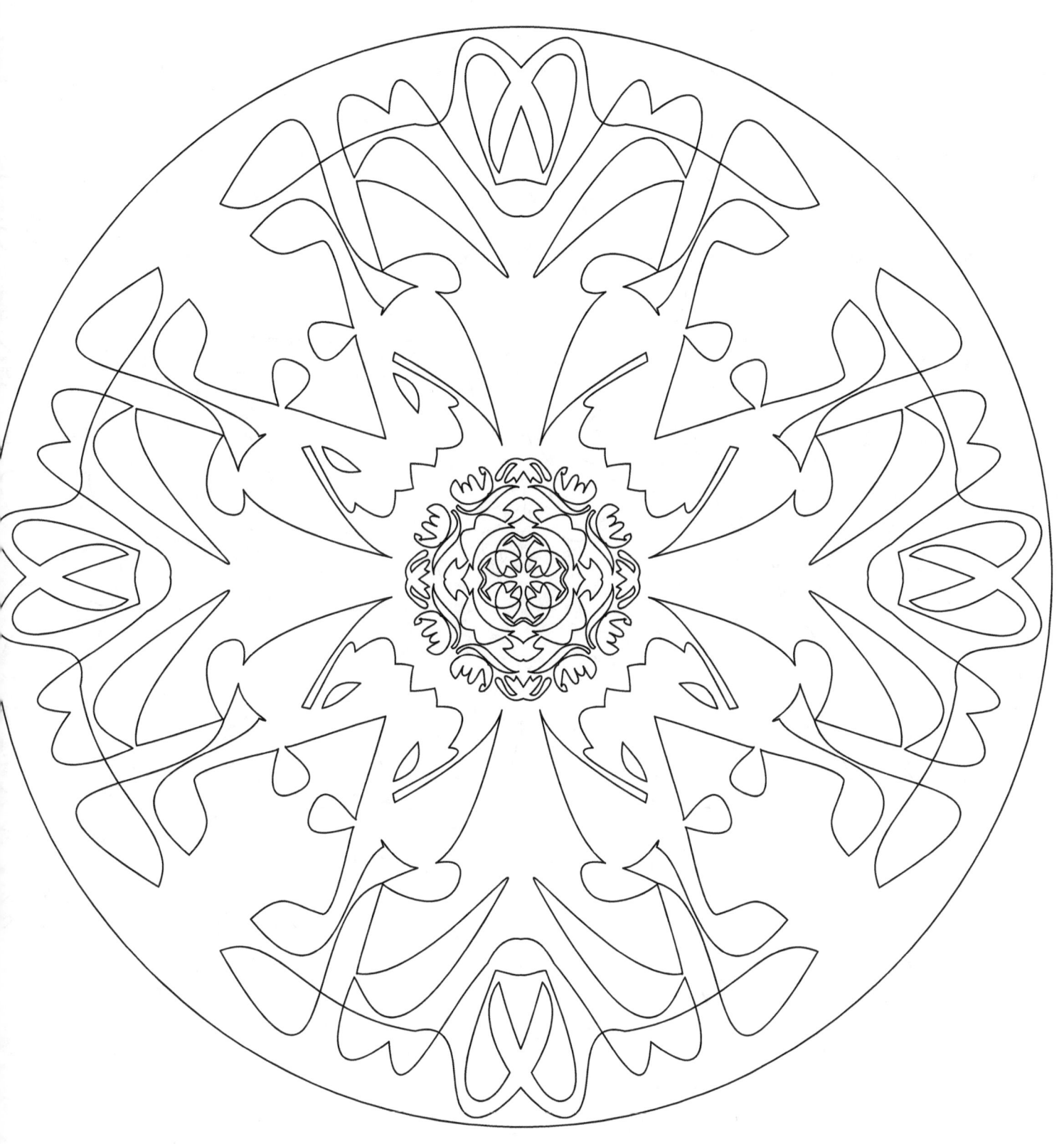

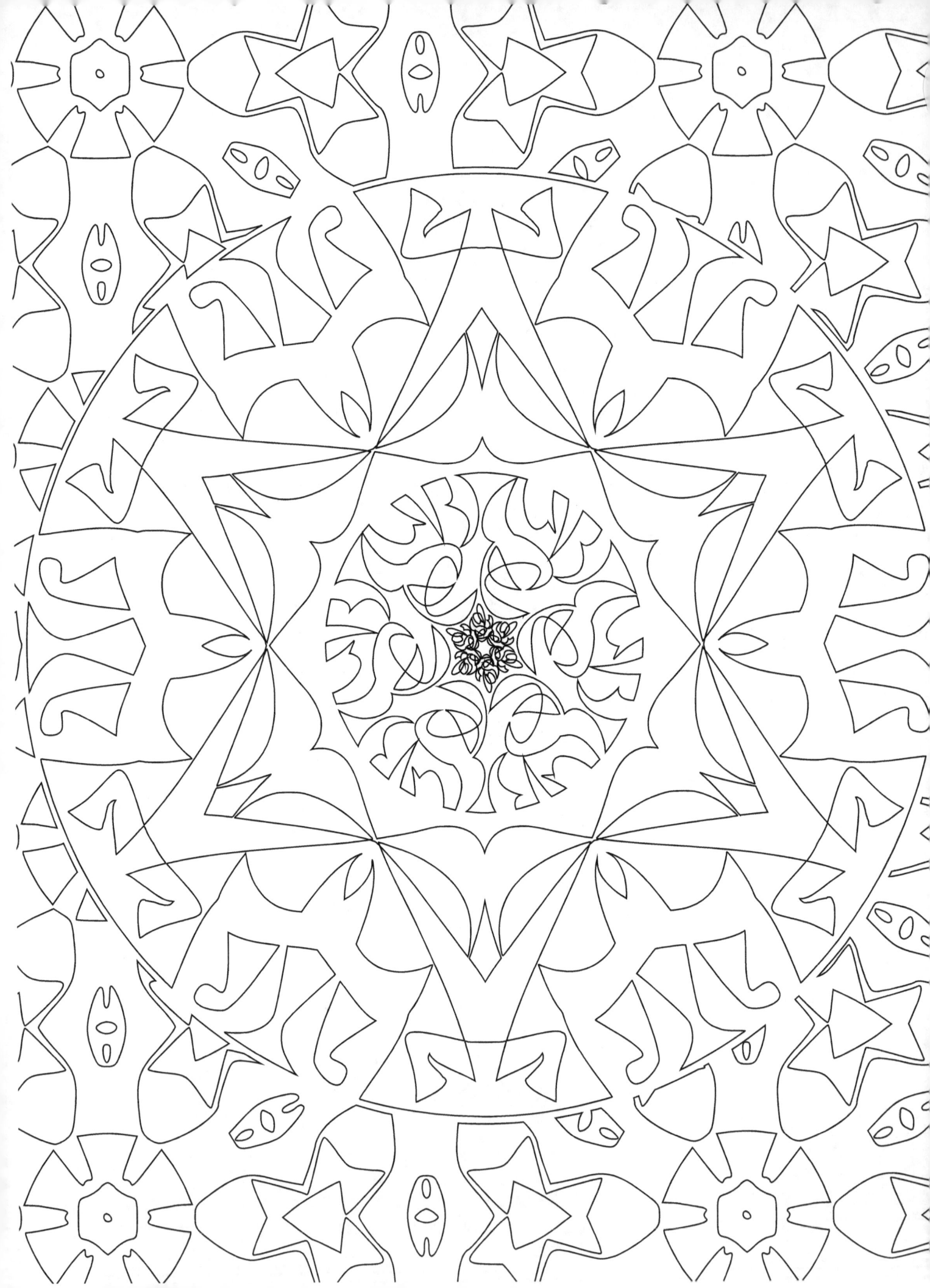

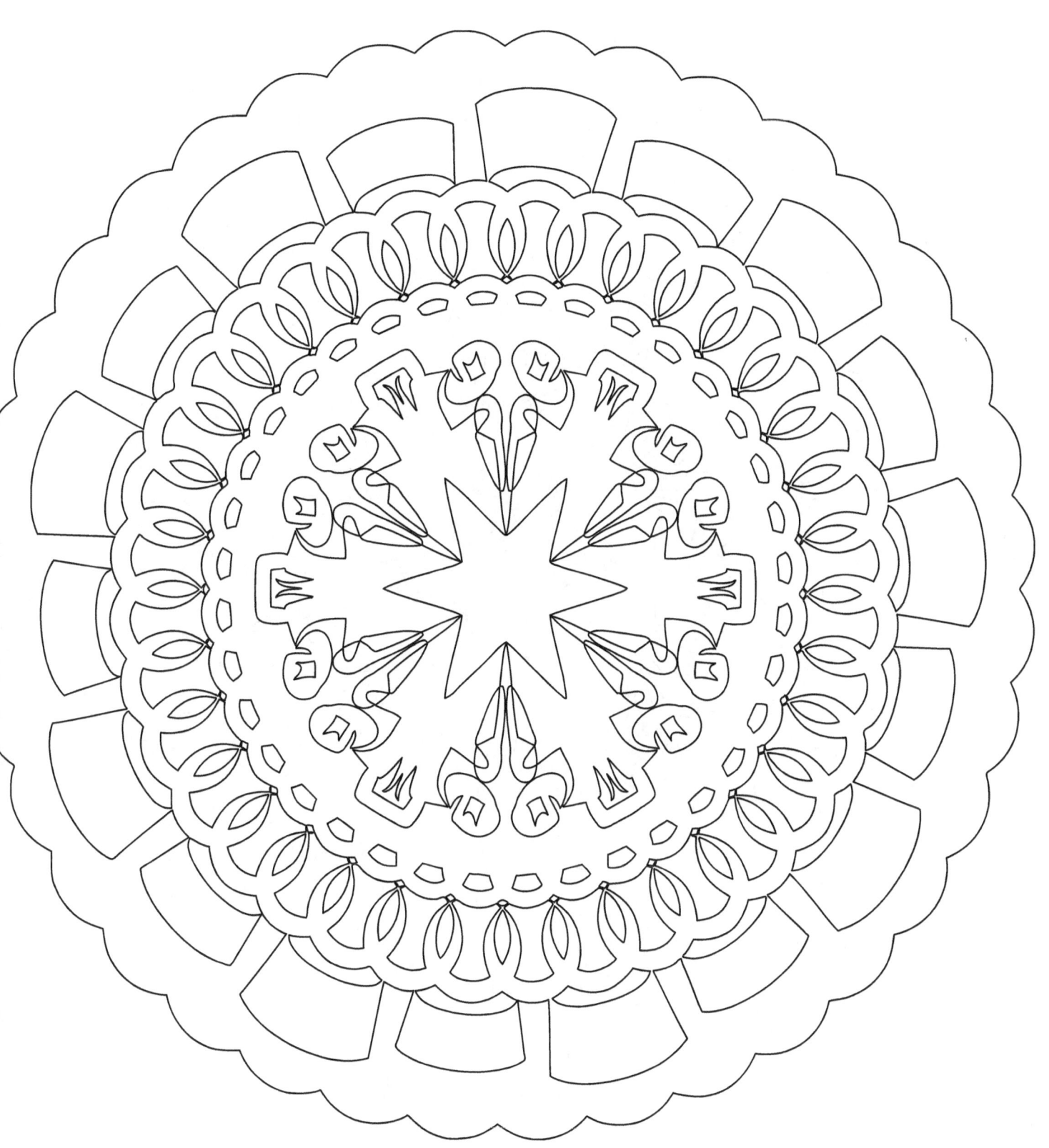

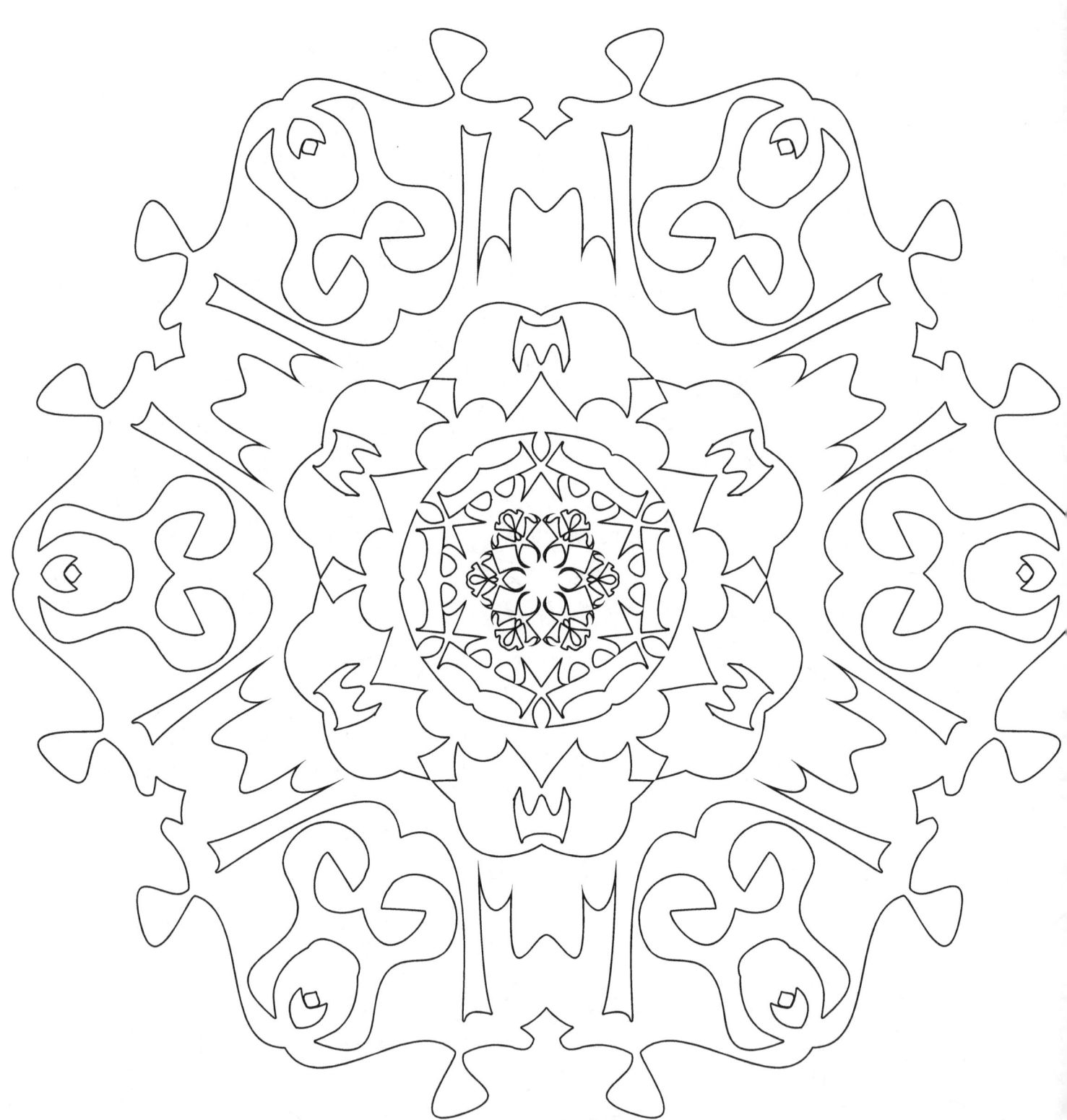

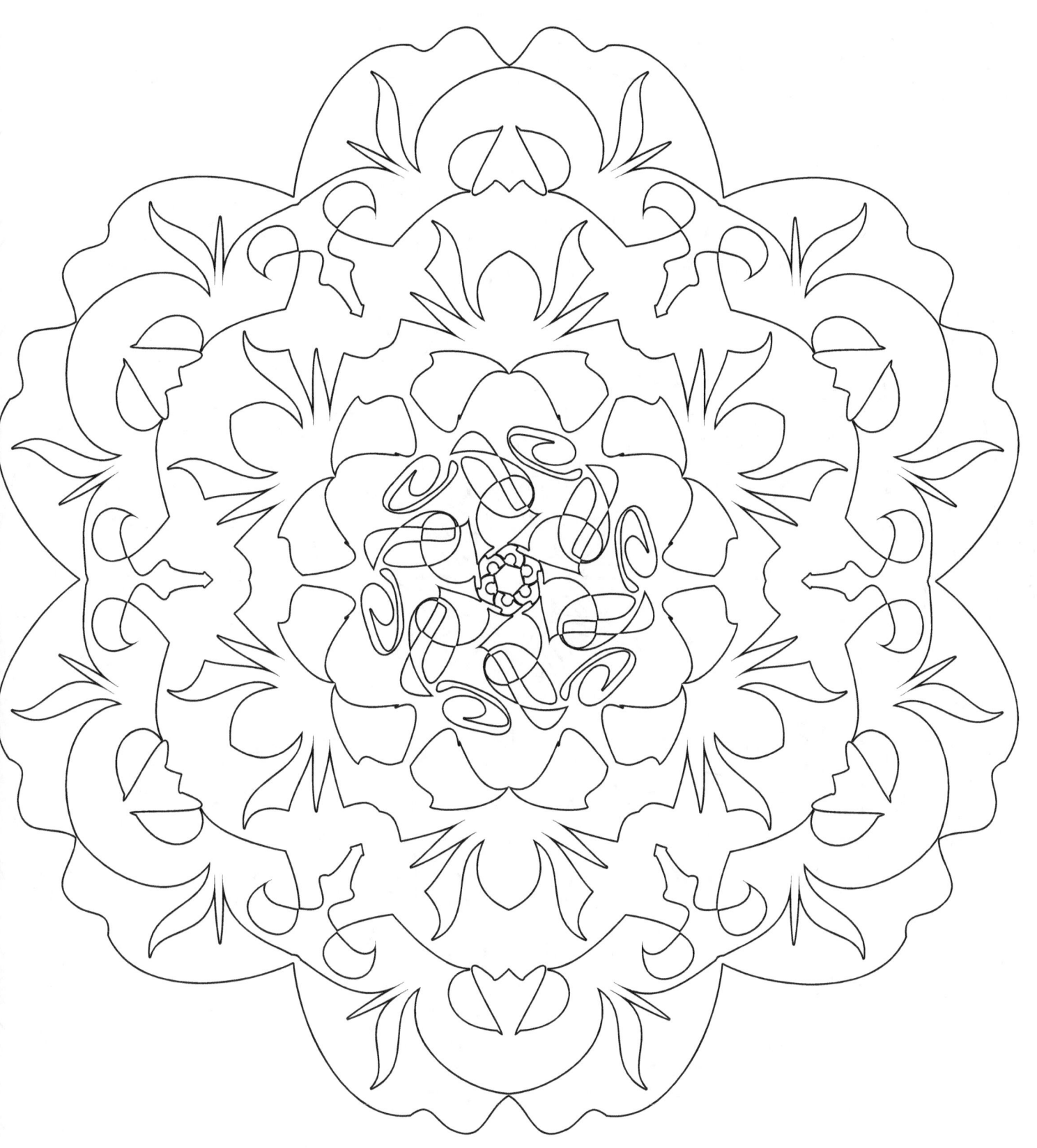

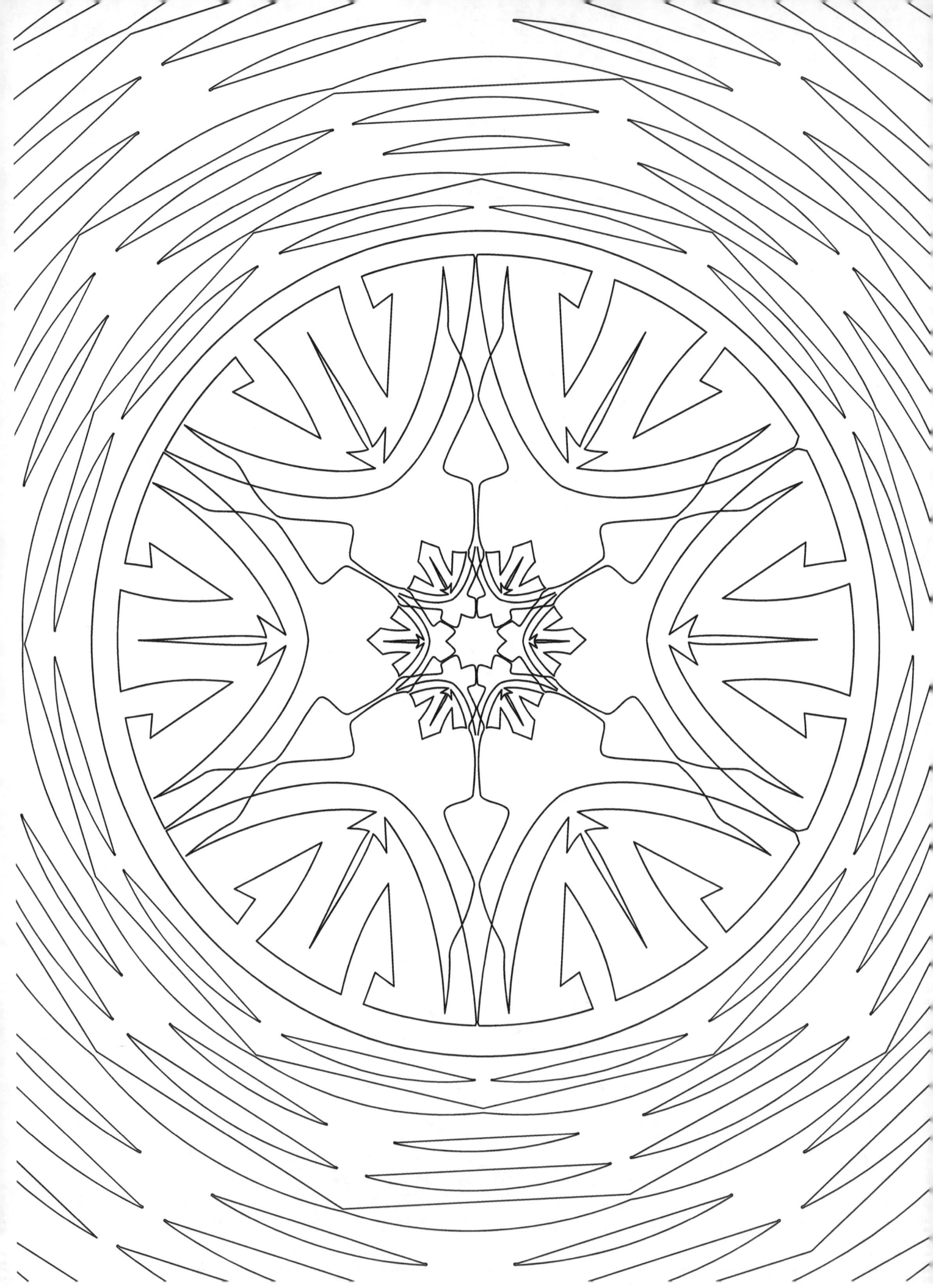

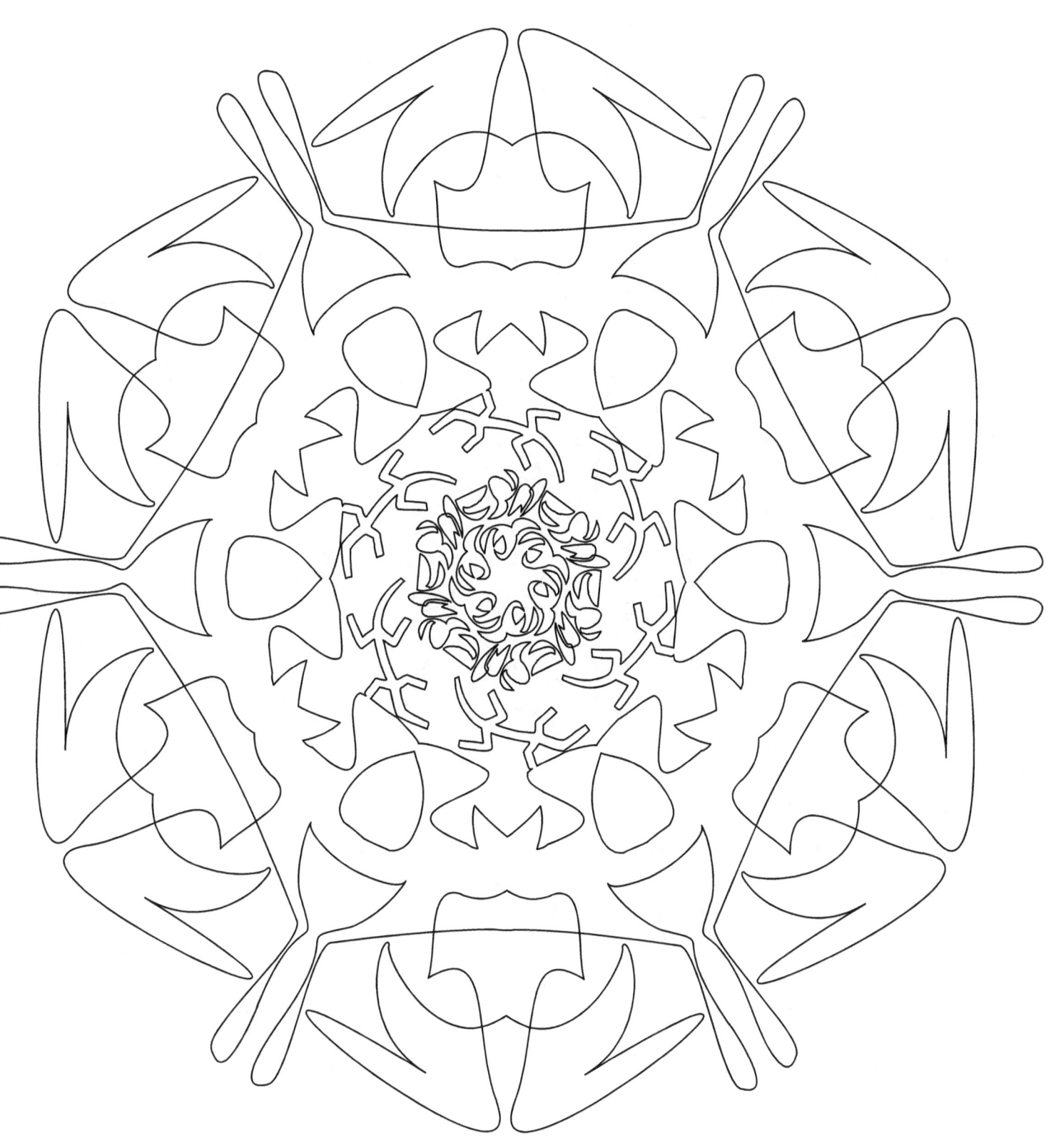

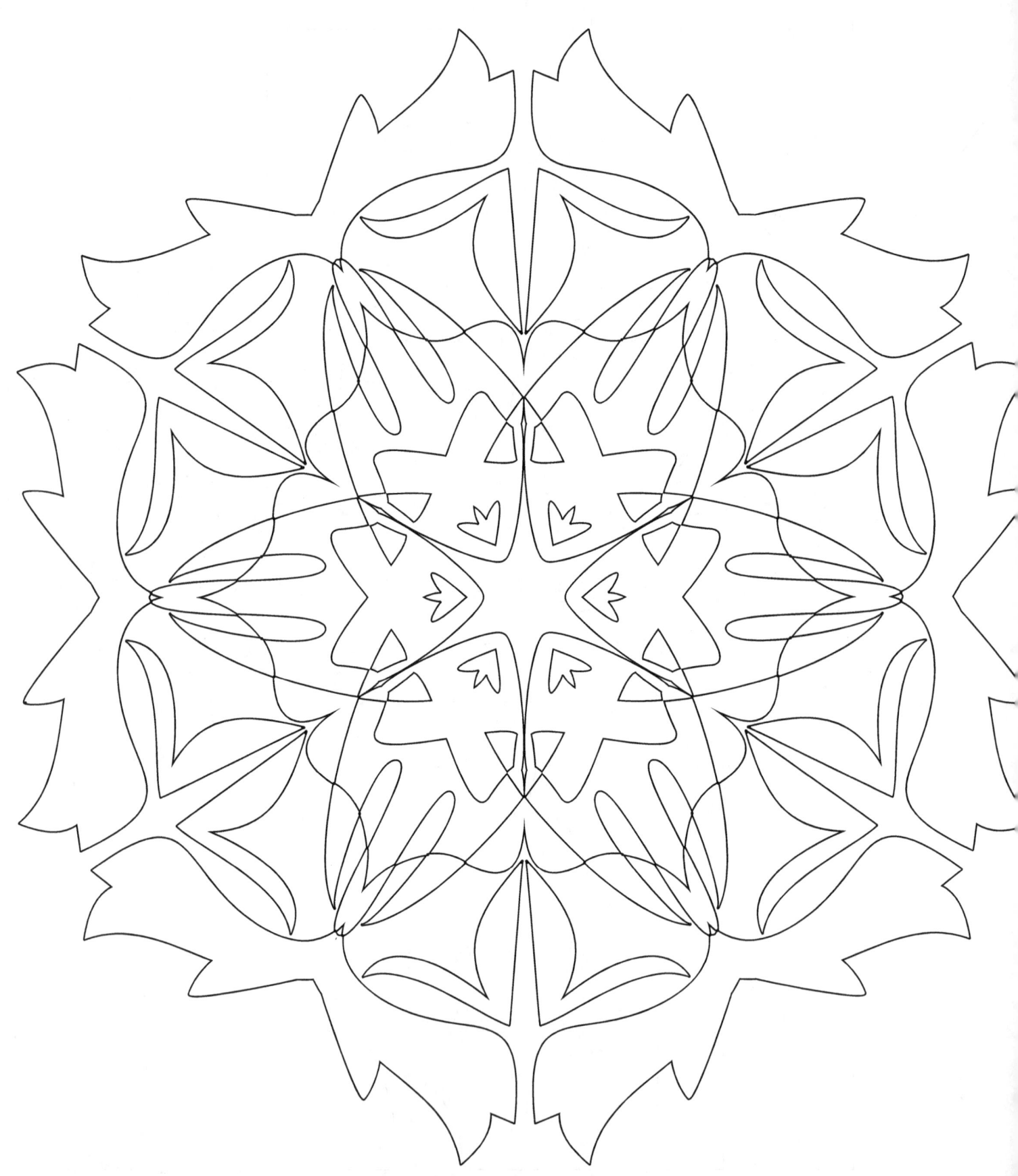

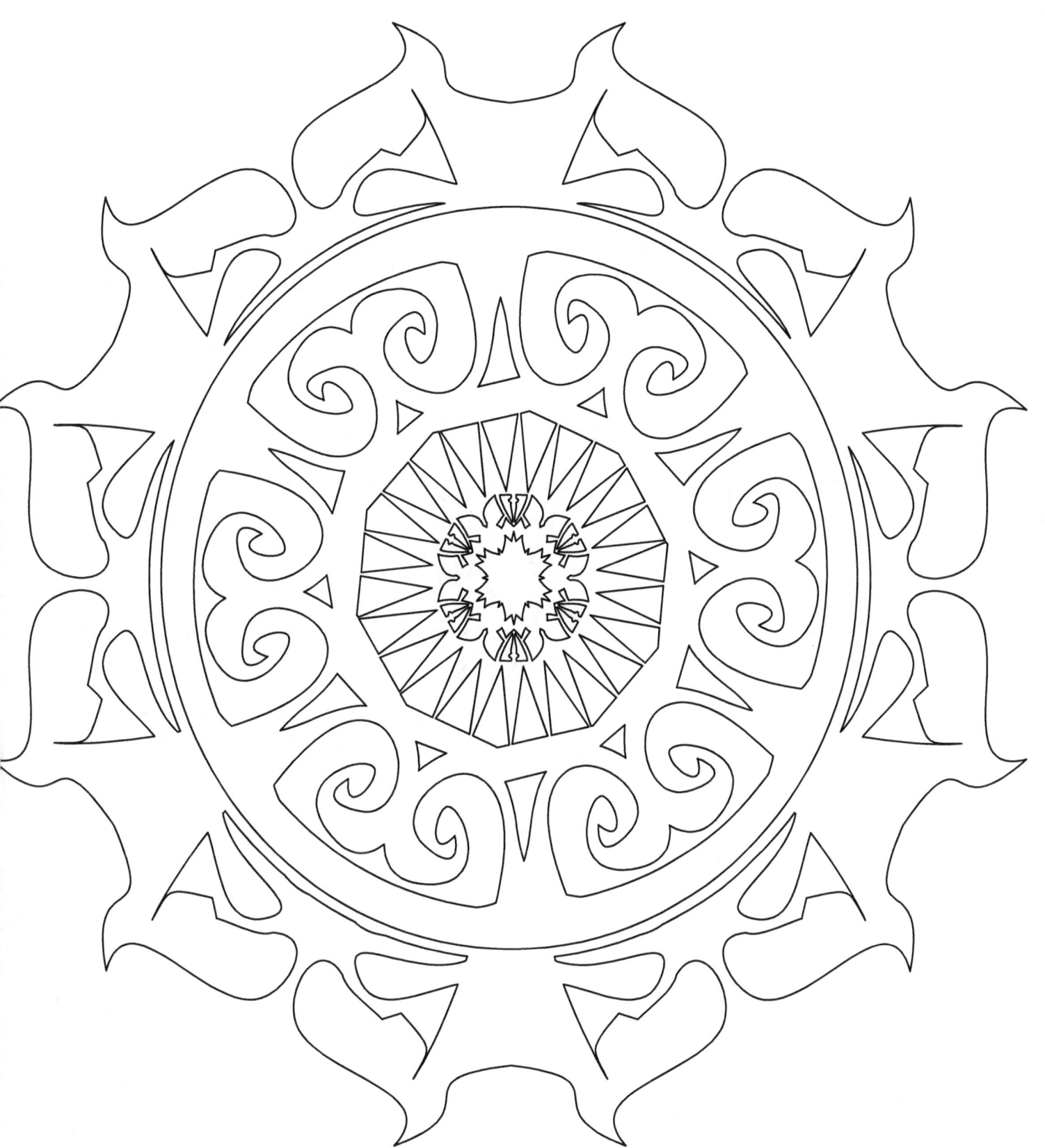

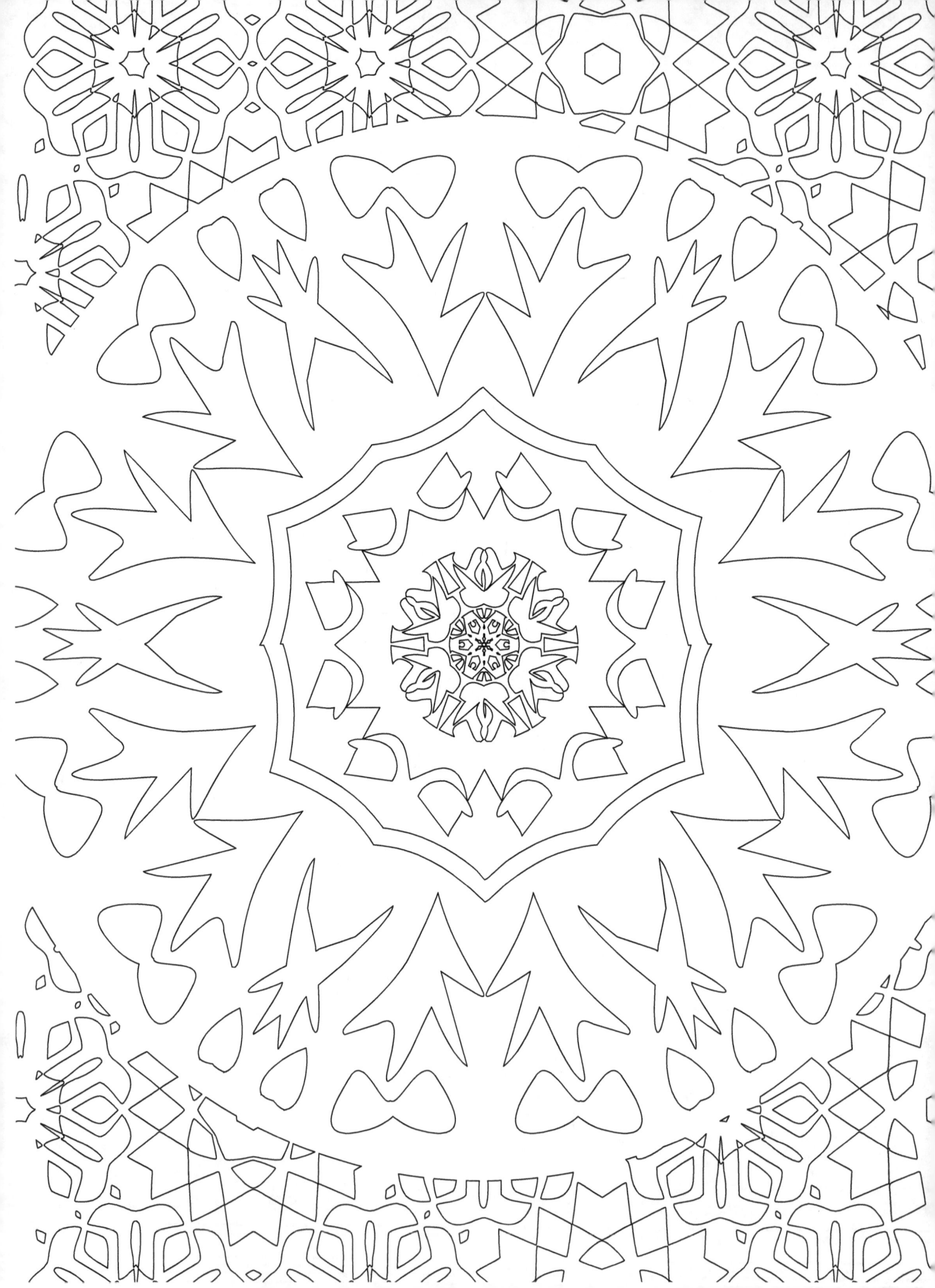

www.ingramcontent.com/pod-product-compliance
Lightning Source LLC
Chambersburg PA
CBHW080609190526
45169CB00007B/2939